The Whole World Is Naturally Curly

A Journey about X-Tasy through the eyes of an Artist

By

Andrea L. Willow

Illustrations by Andrea L. Willow

THIS BOOK IS PUBLISHED BY ANDREA L. WILLOW

"*The Whole World is Naturally Curly*". Copyright © 2013 by Andrea L. Willow. All rights reserved. Published in the United States by Andrea L. Willow. No part of this book may be reproduced by any mechanical, photographic, or electronic process, or in the form of a phonographic recording; nor may it be stored in a retrieval system, transmitted, or otherwise be copied for public use without prior written permission of the author and publisher.

The intent of the author is only to offer inspiration via her artwork. In the event you use any of the information in this book for yourself, the author and the publisher assume no responsibility for your actions.

Book cover is designed by Andrea L. Willow
Illustrations by Andrea L. Willow

Library of Congress Cataloging-in-Publication Data available upon request.
ISBN 978-1484079560
ISBN 1484079566

Printed in the United States of America

April 2013

Dedication

This book is dedicated to my special friends and family members who have kindly and gently supported me through the years while venturing on my journey.

Acknowledgments

I would like to acknowledge the many programs, seminars, groups, and drum circles I have participated in over the years. Thus, the combined experiences have allowed me to search and understand more of humanity with all its complexities.

Mary Scott who formatted the interior pictures, text, book covers, and put the entire book together electronically to be published.

Author's Note:

This book reflects only my light-hearted point of view in observing and experiencing life.

This book is a compilation of inspirational artwork I did in 1979 under the copyright VAu000007813 / 1979-06-11.
- Andrea L. Willow

INTRODUCTION

What is X-Tasy?

X-Tasy can be any shape, size, color, person, non-person, experience, and/or non-experience. X-Tasy has no limitations. X-Tasy does not belong to any particular group of individuals. X-Tasy is whatever you wish it to be. X-Tasy is magic. X-Tasy may not be what you think it is. X-Tasy is who you are and who you are not.

QUESTION: Why is the Whole World Naturally Curly?
ANSWER: Because everything has a kink in it.

Come with me, my friend, and cruise X-Tasy through the eyes of an Artist.

- Andrea L. Willow

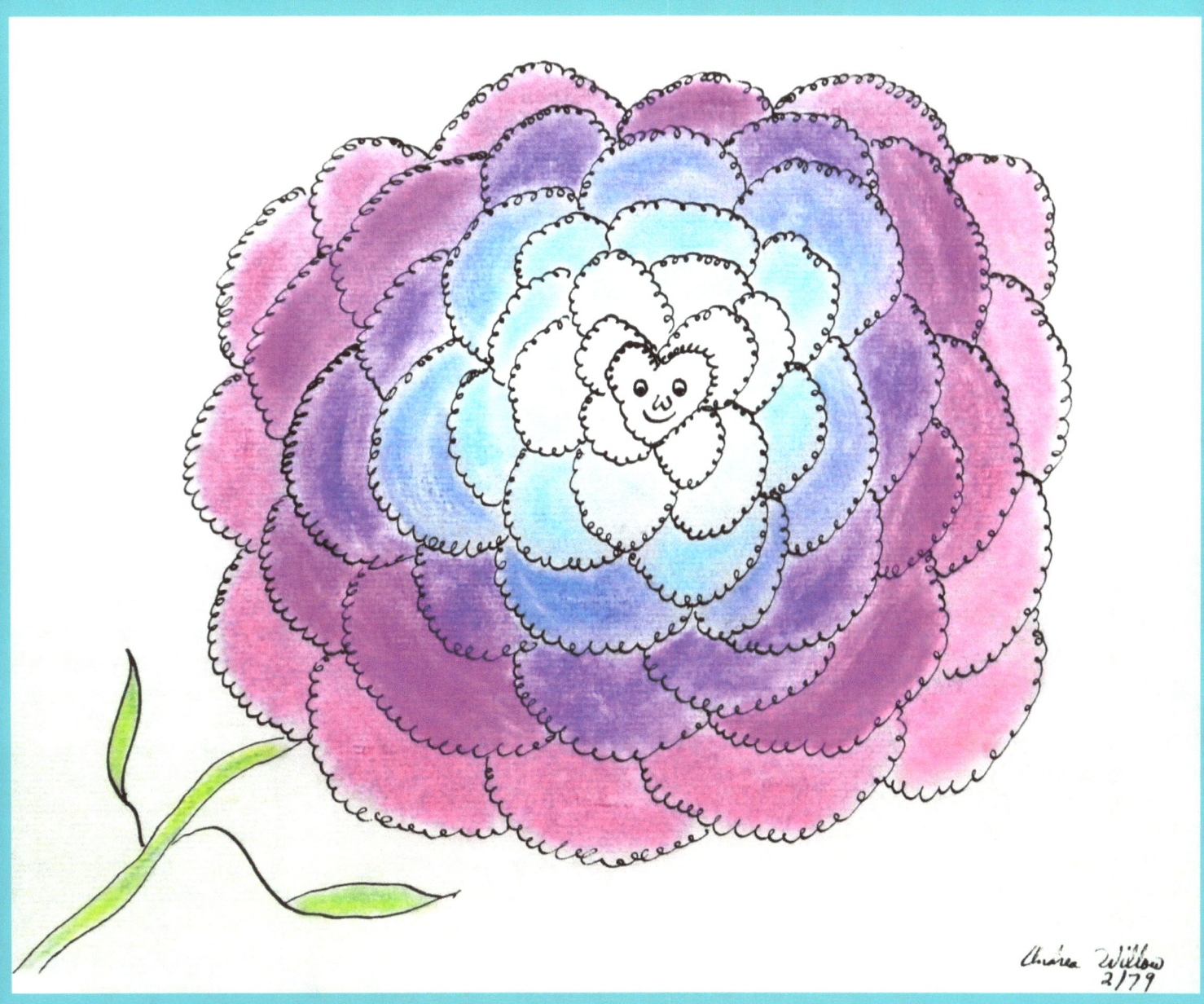

X-Tasy is knowing a rose opens up so you can love it.

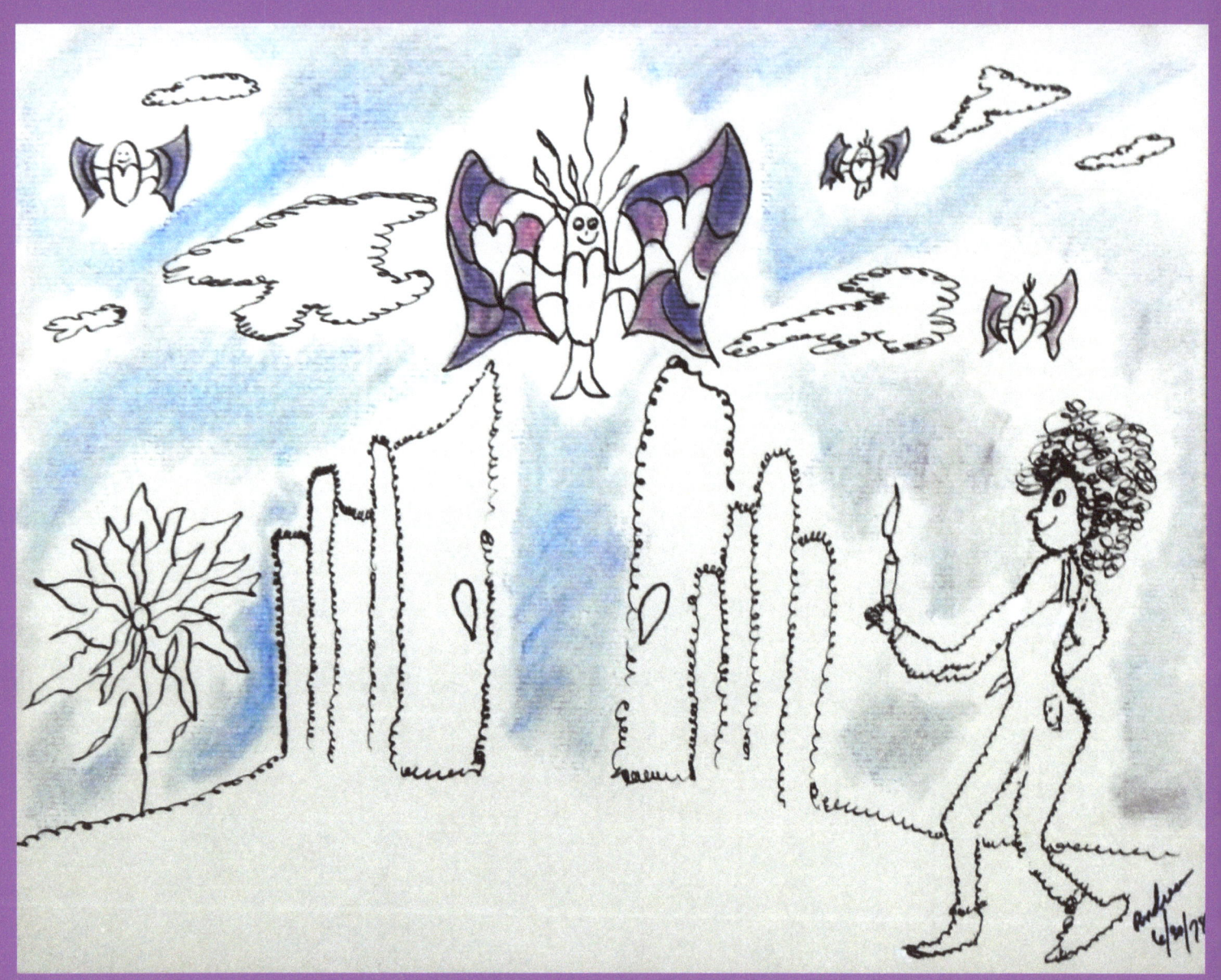

X-Tasy is knowing a friend name L.I.T.E.
(Short for --- Luckily I Transformed Effortlessly).

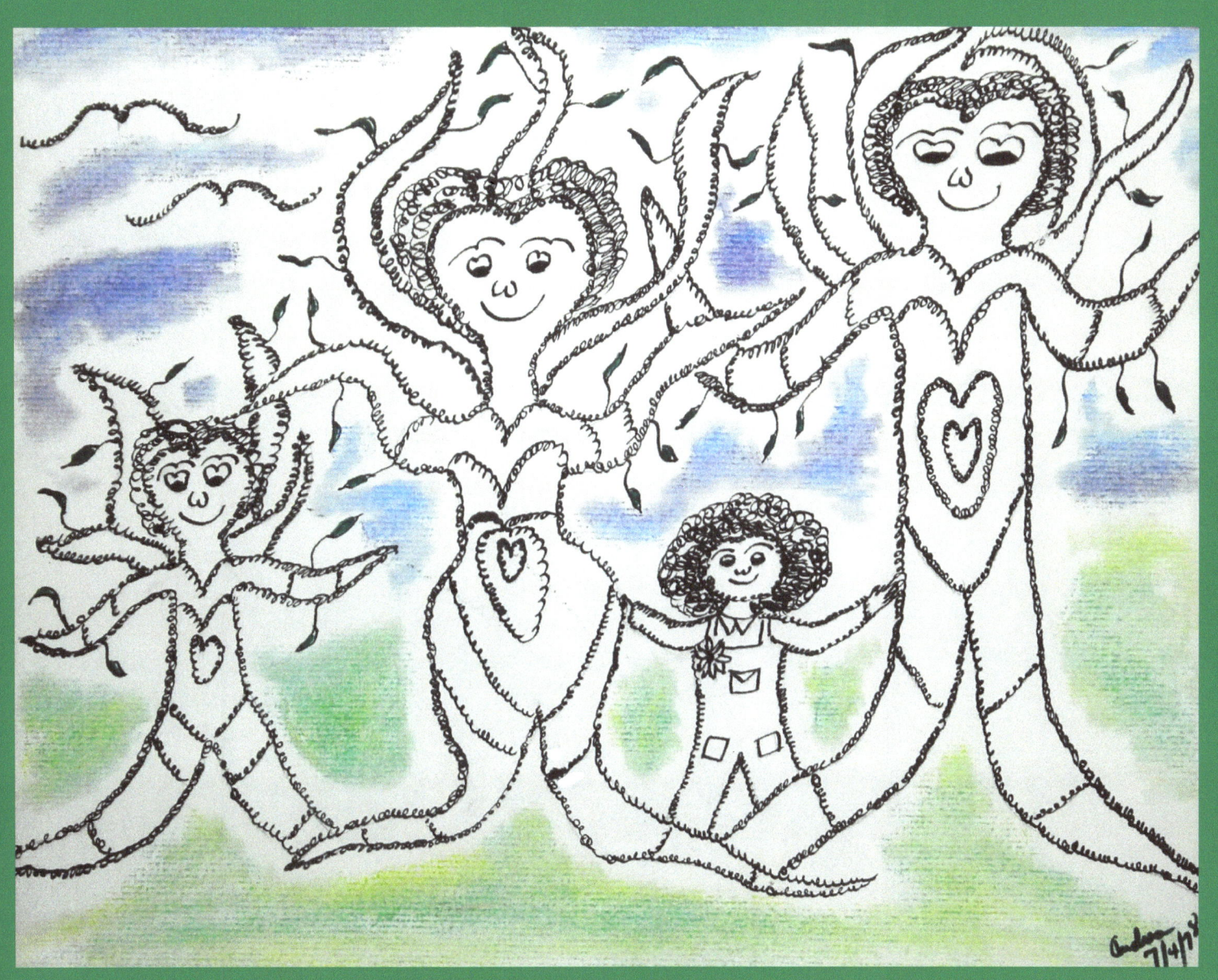

X-Tasy is knowing you are part of the family tree.

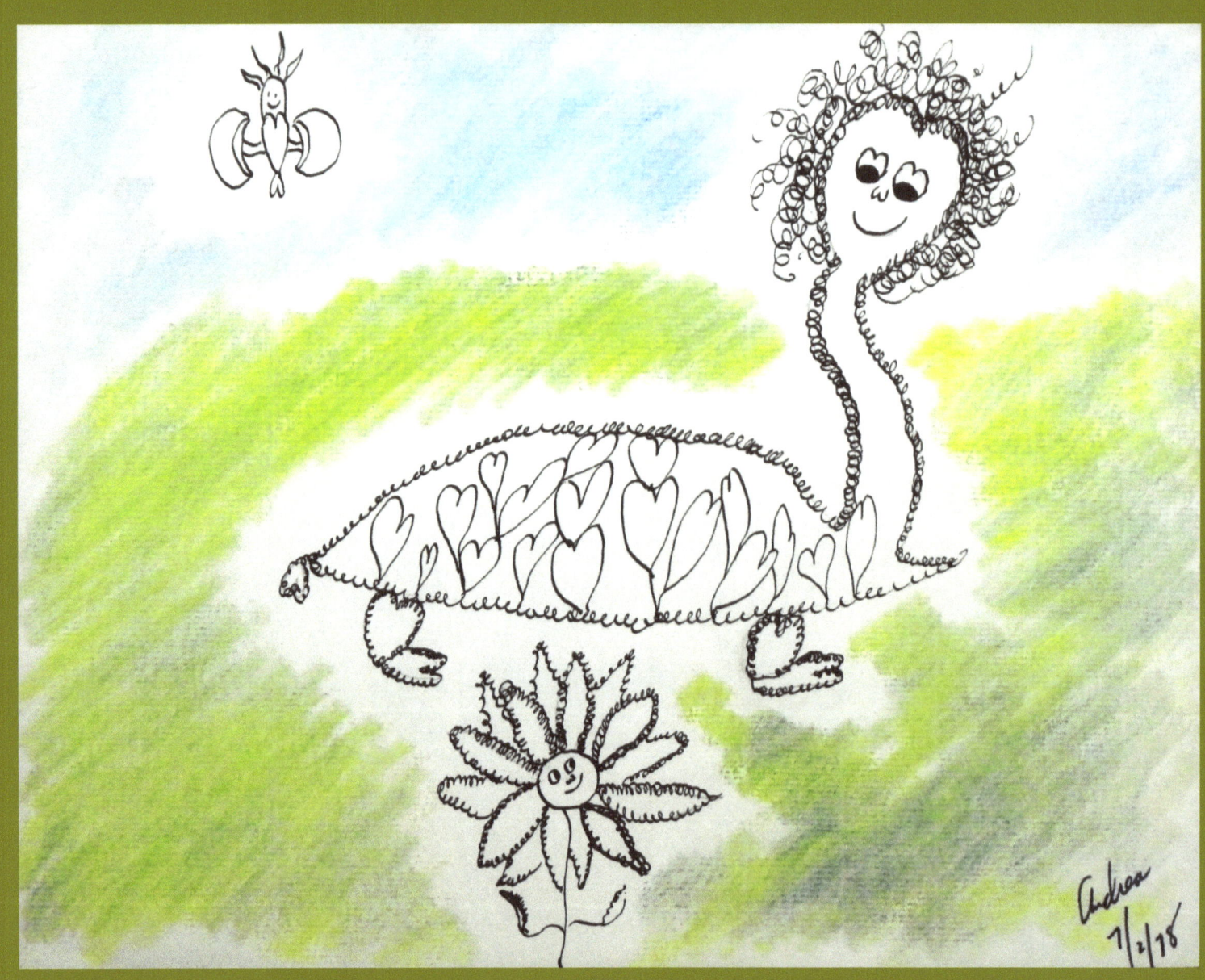

X-Tasy is knowing you are always acknowledged.

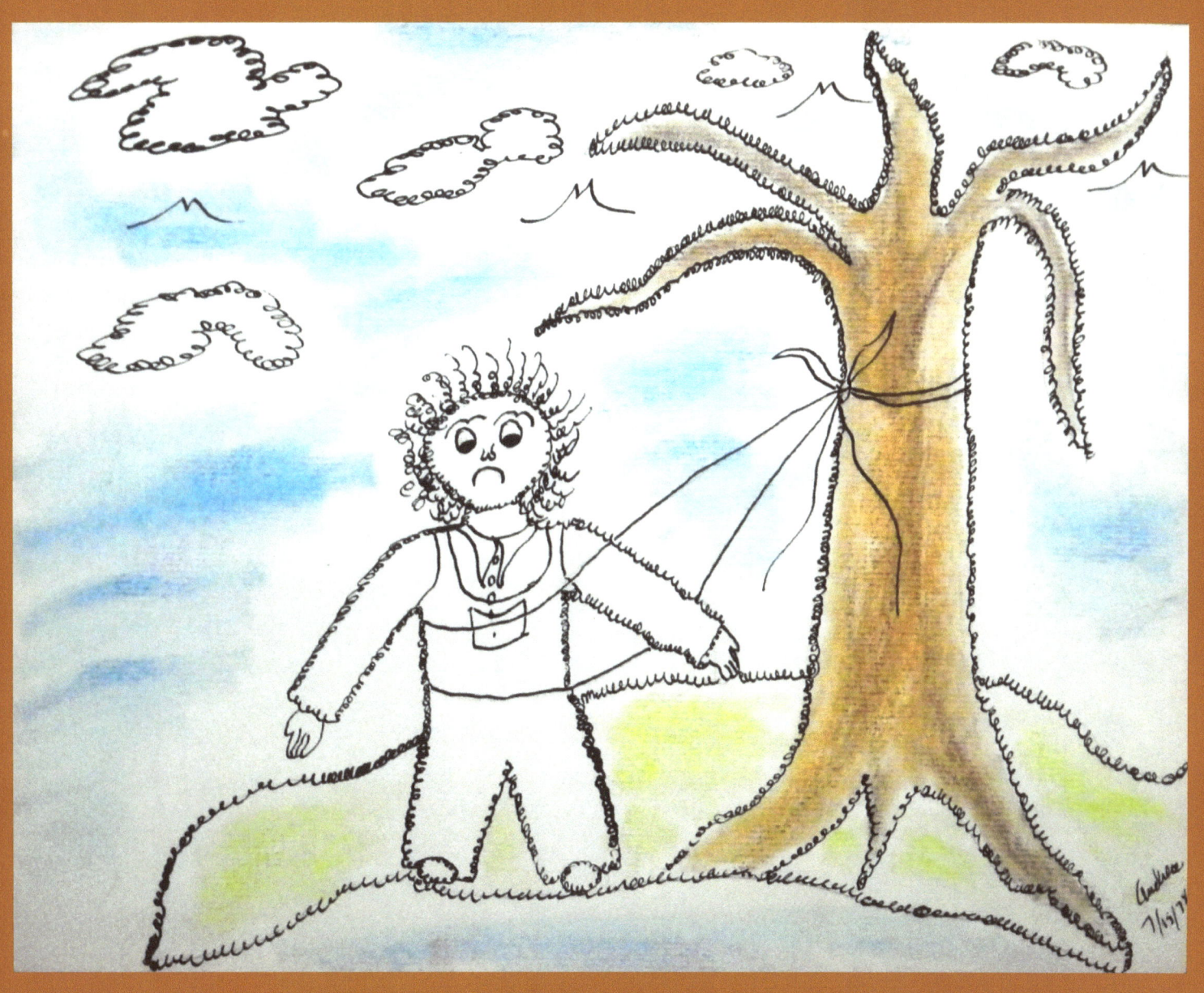

X-Tasy is knowing that being stuck is ok,
and sometimes it doesn't feel like play.

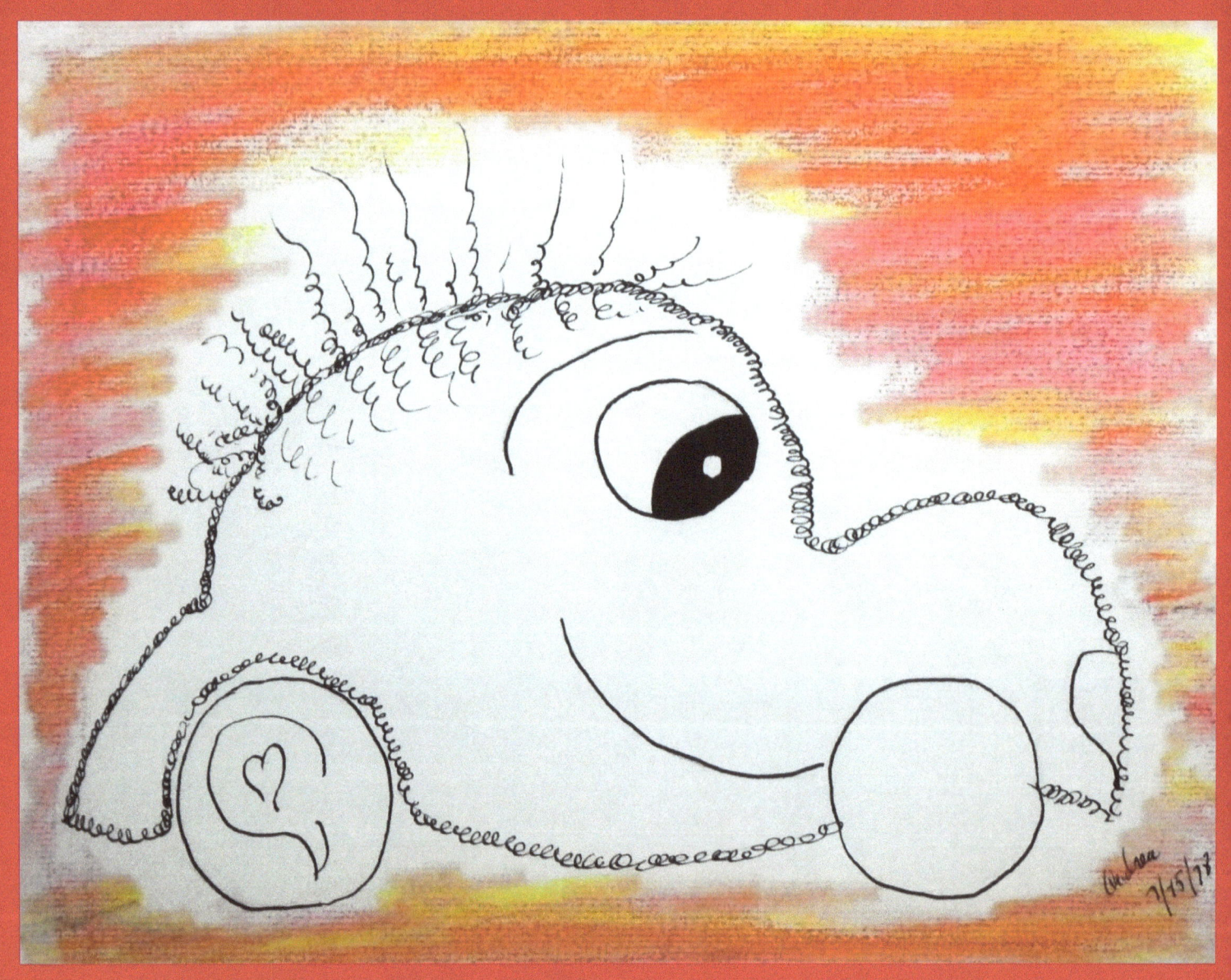

X-Tasy is knowing that your car (named Car-A-Loose) always tells the truth.

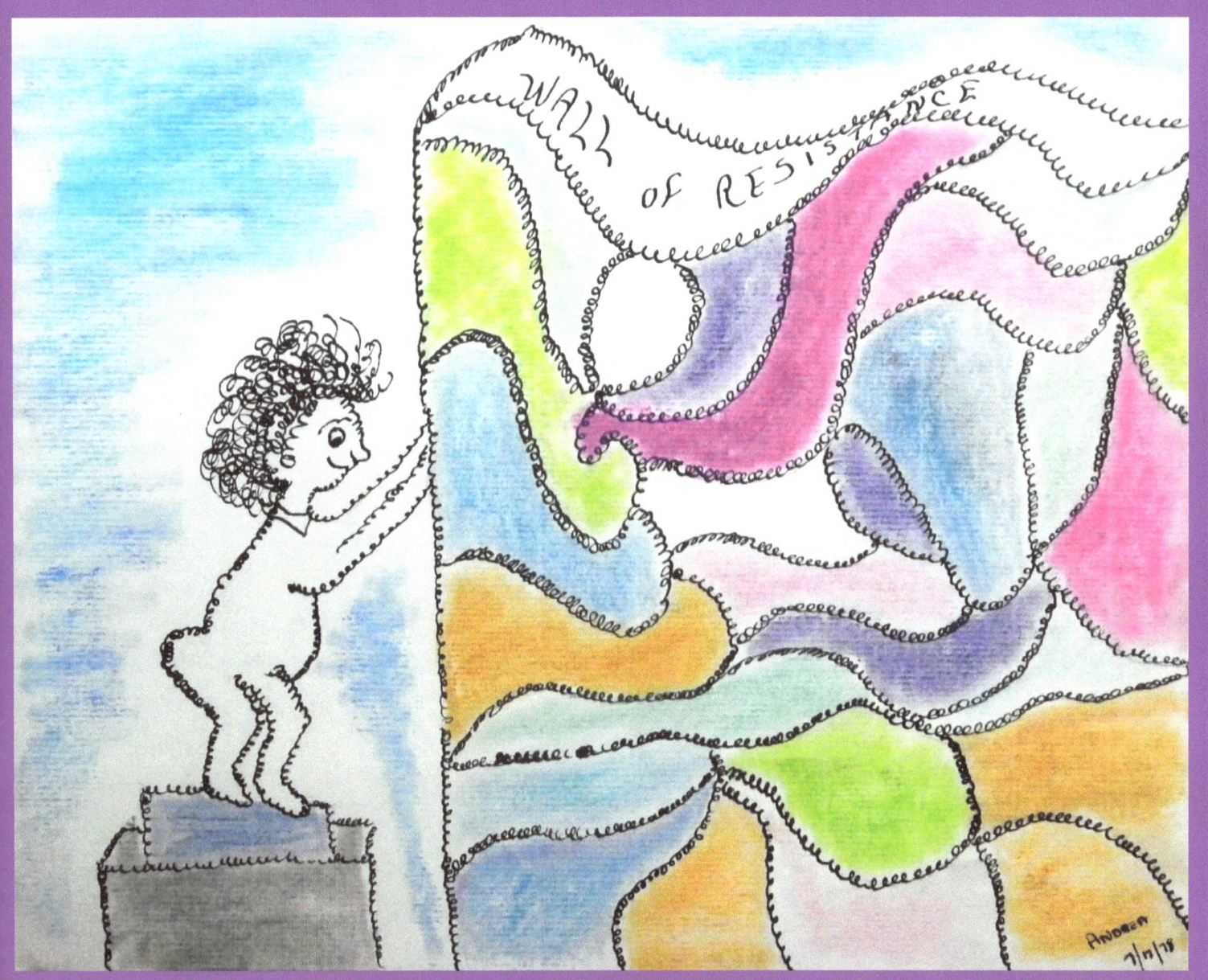

X-Tasy is knowing even what you resist has great beauty.

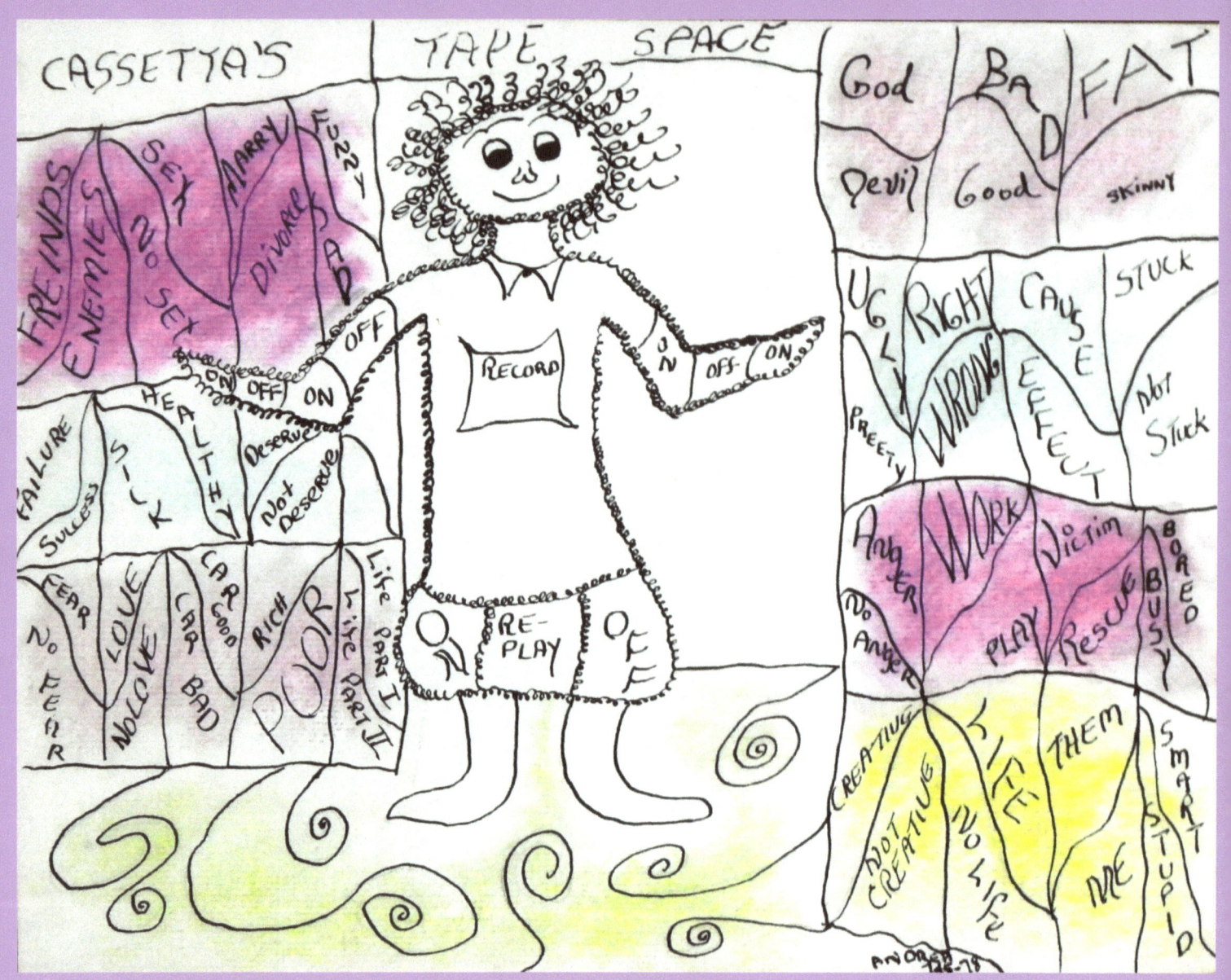

X-Tasy is knowing you never run out of tapes.

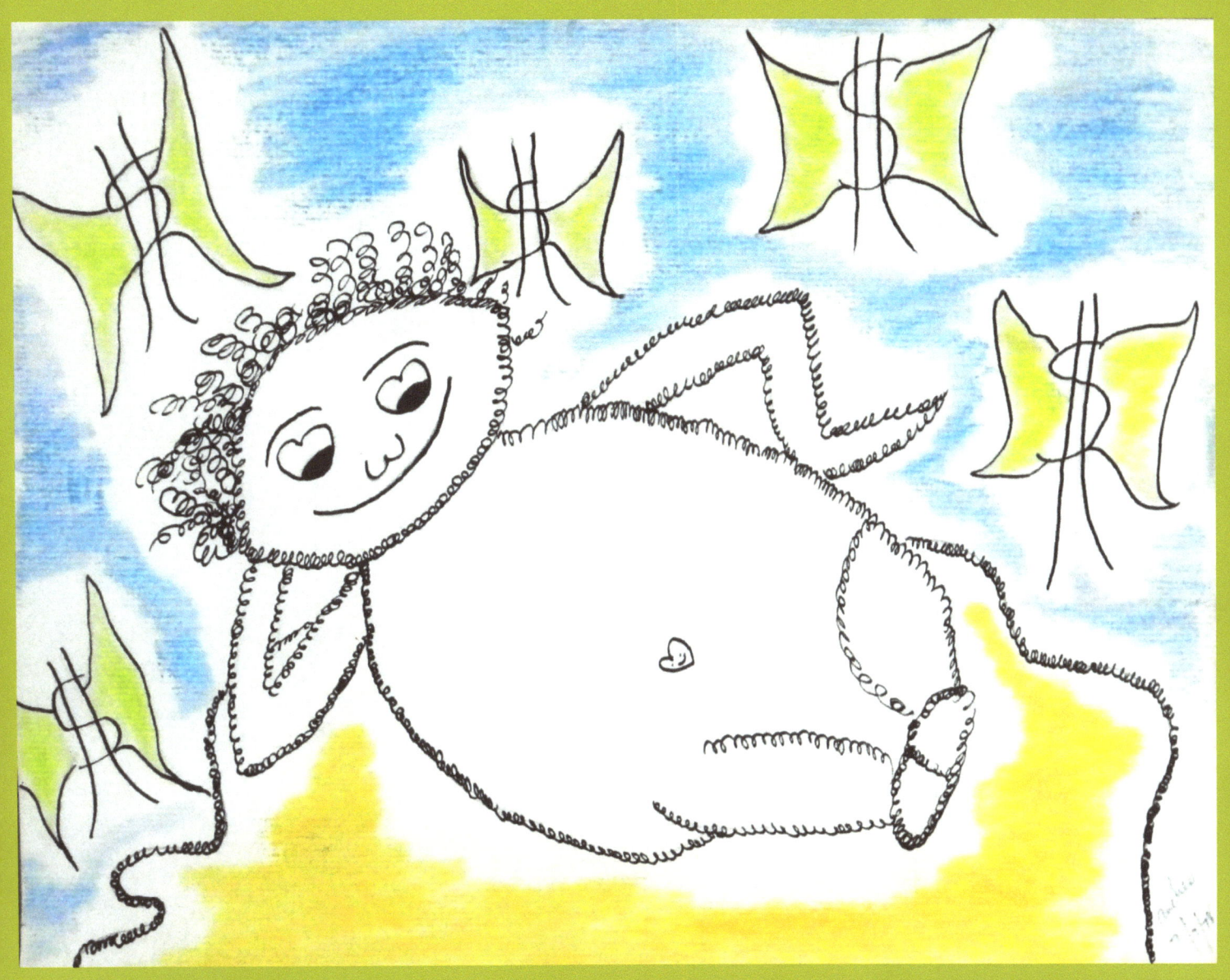

X-Tasy is knowing you don't have to do anything to be a zillionaire --- just be who you are.

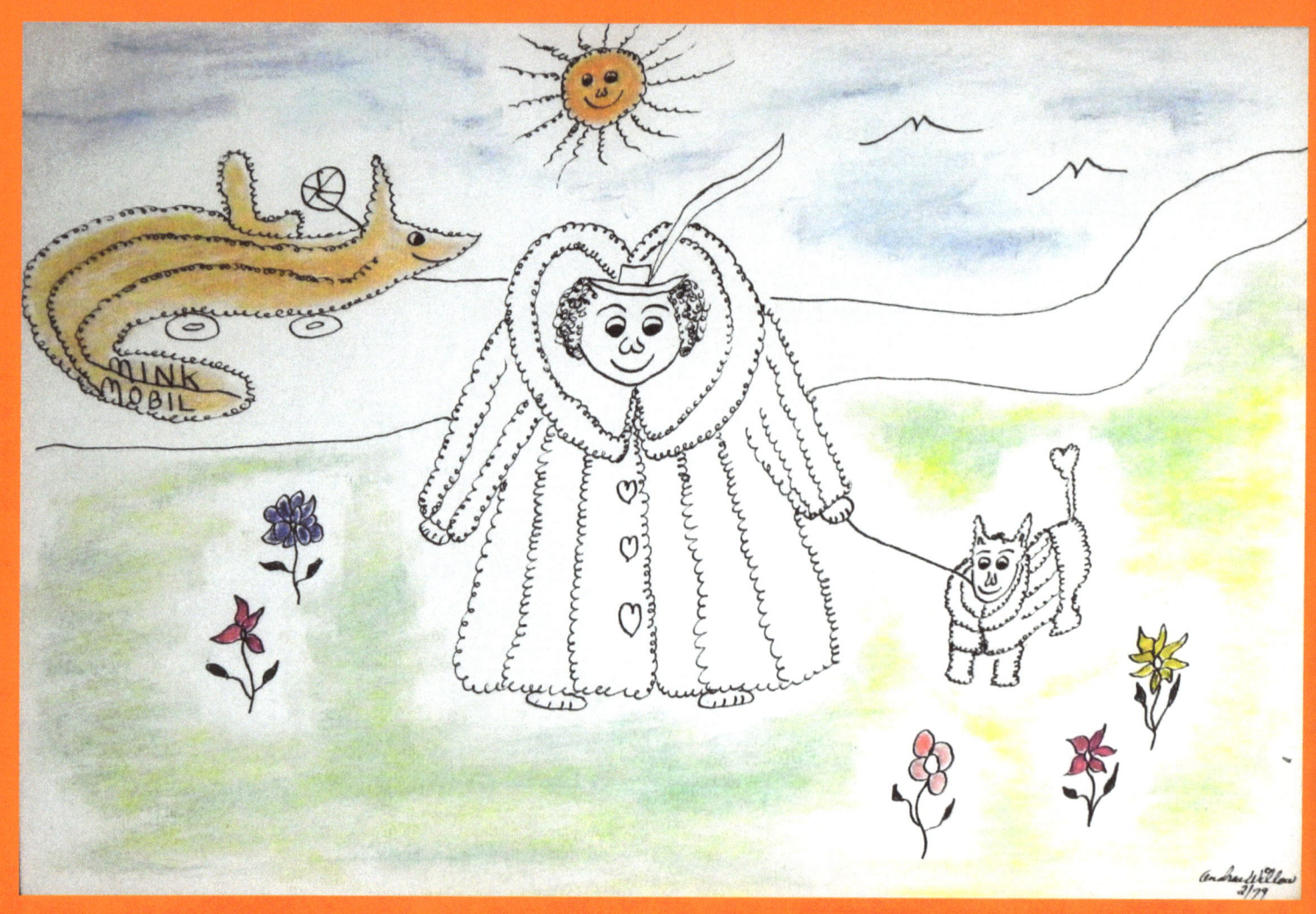

X-Tasy is knowing you have mink-coat-karma.

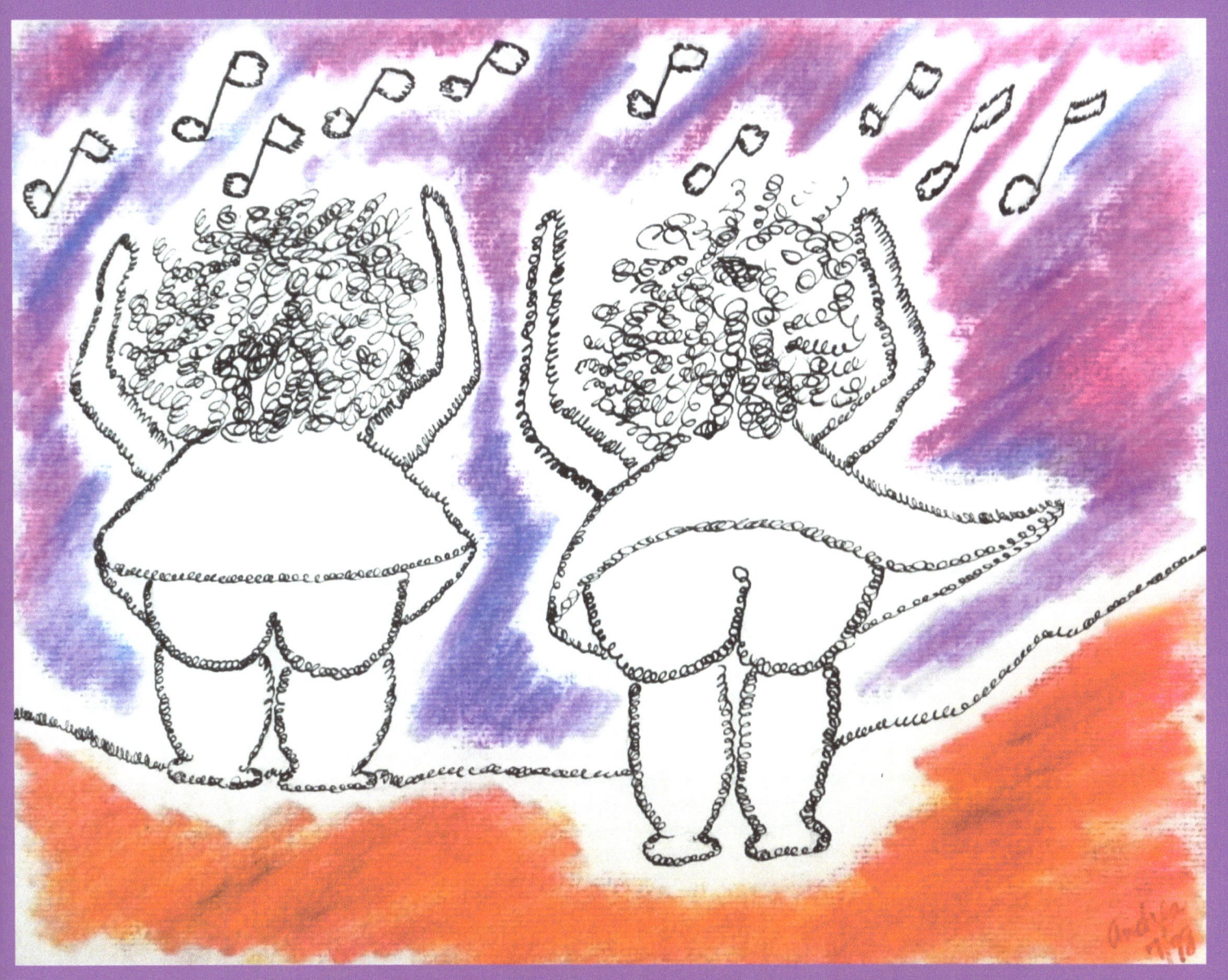

X-Tasy is knowing it's ok to have a fat fanny, after all,
a fat fanny is just a heart turned upside down!

X-Tasy is knowing you are not a phoney.

X-Tasy is getting into the swim of things.

X-Tasy is knowing you are still a kid.

X-Tasy is knowing you really are all heart.

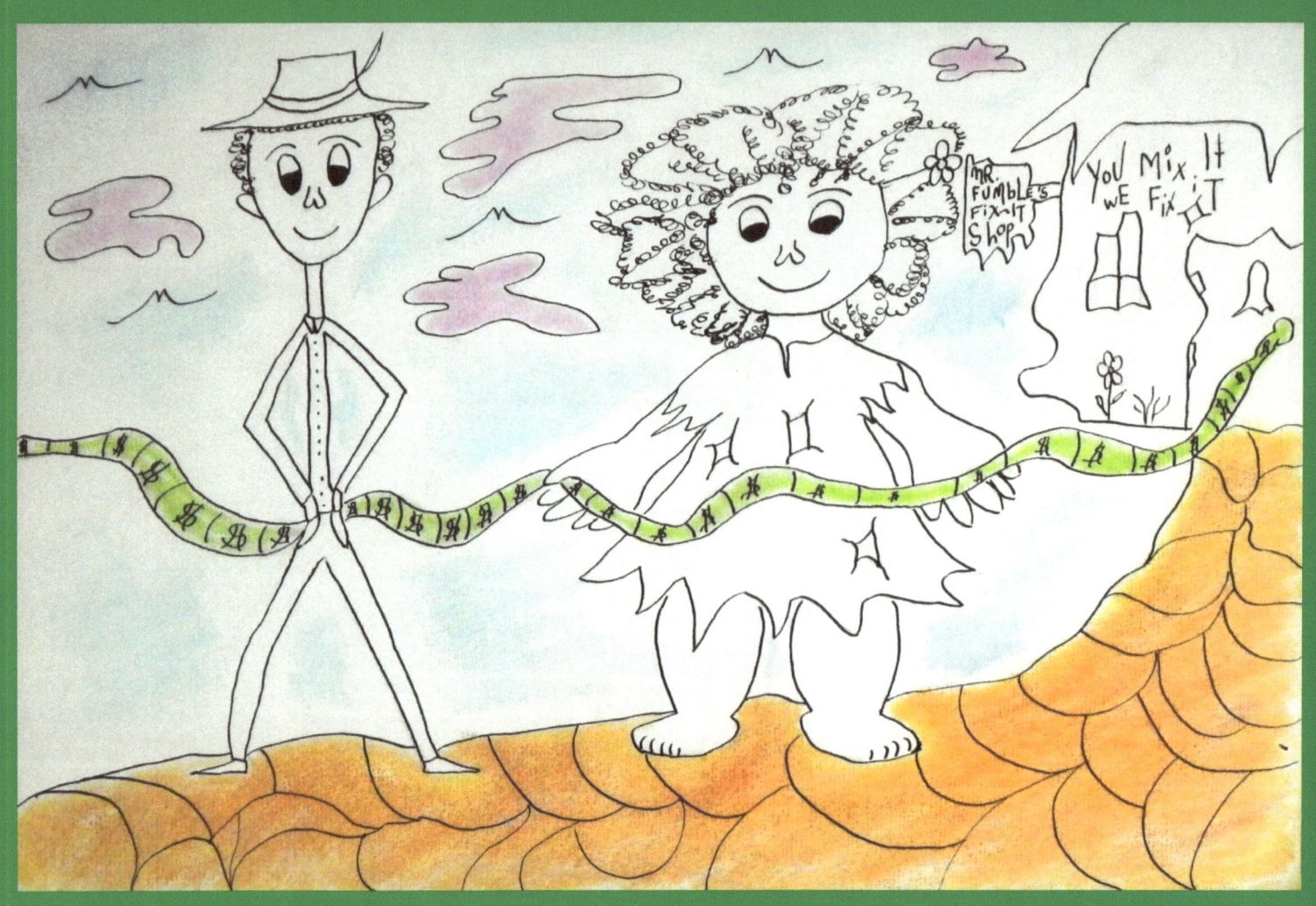

X-Tasy is knowing it's ok to be Sheer-Sucker-Sam or Hand-Out-Hilda.

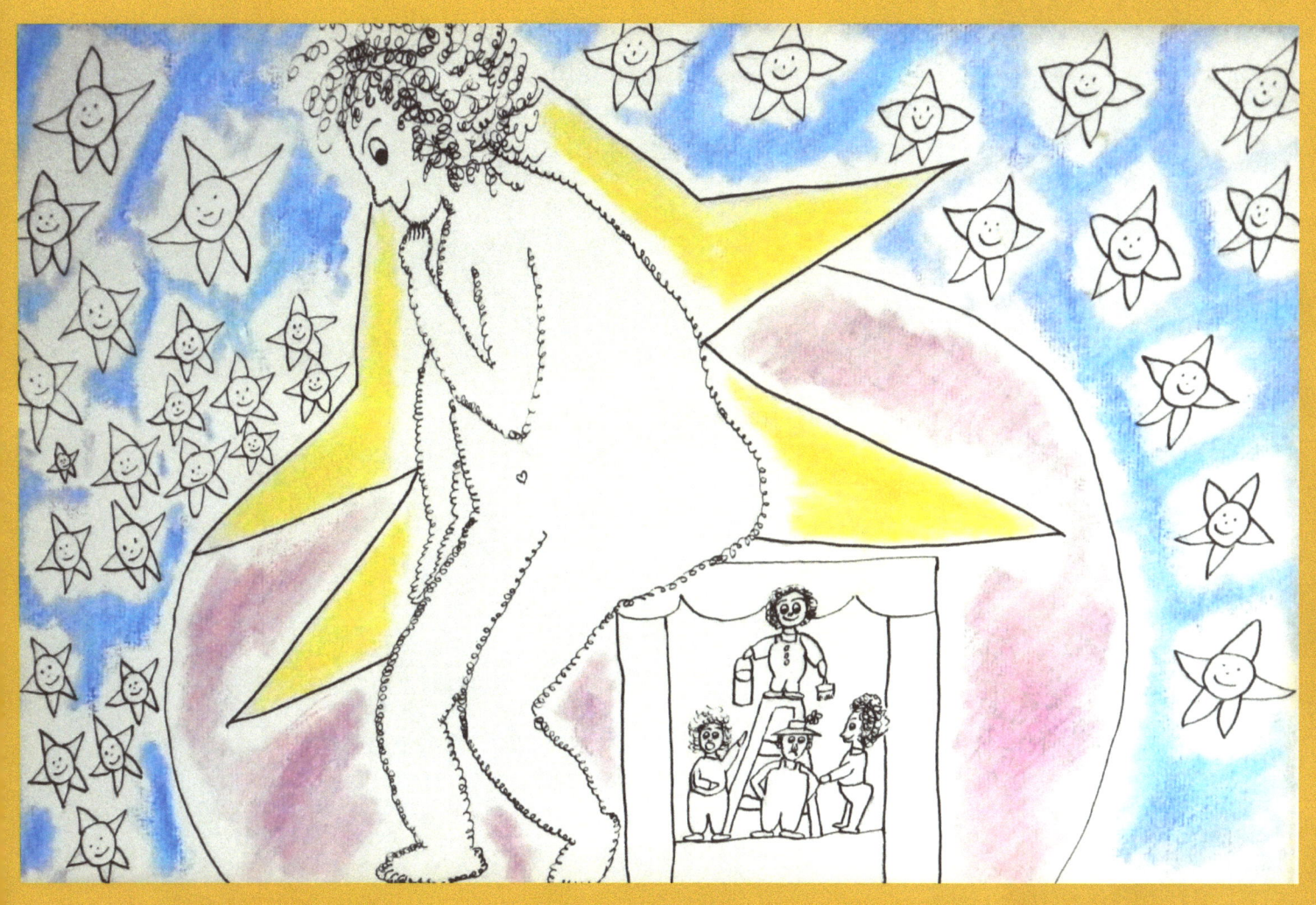

X-Tasy is knowing you can get off your act ---
you're already a star.

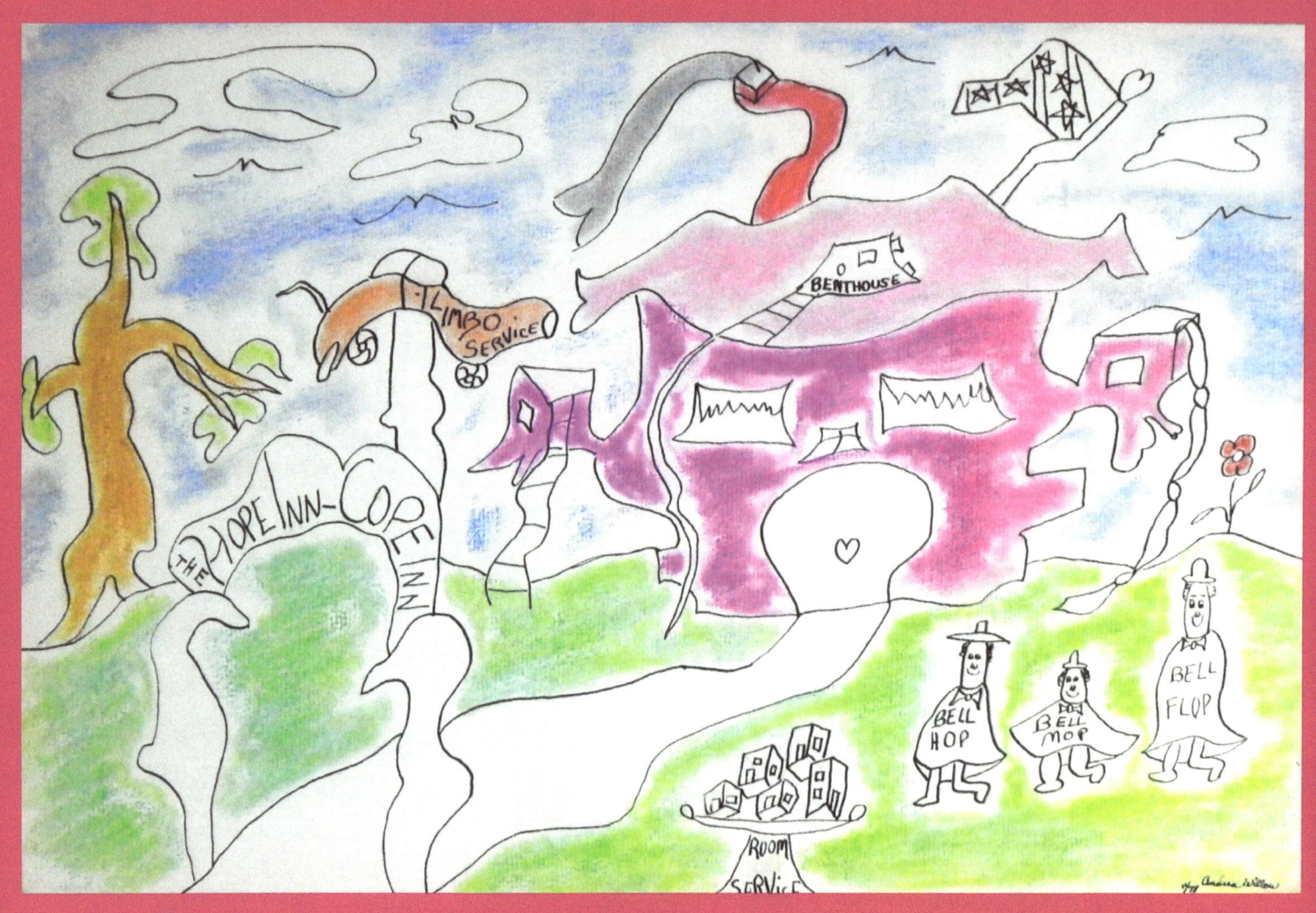

X-Tasy is knowing it's ok to stay at the Hope-Inn Cope-Inn.

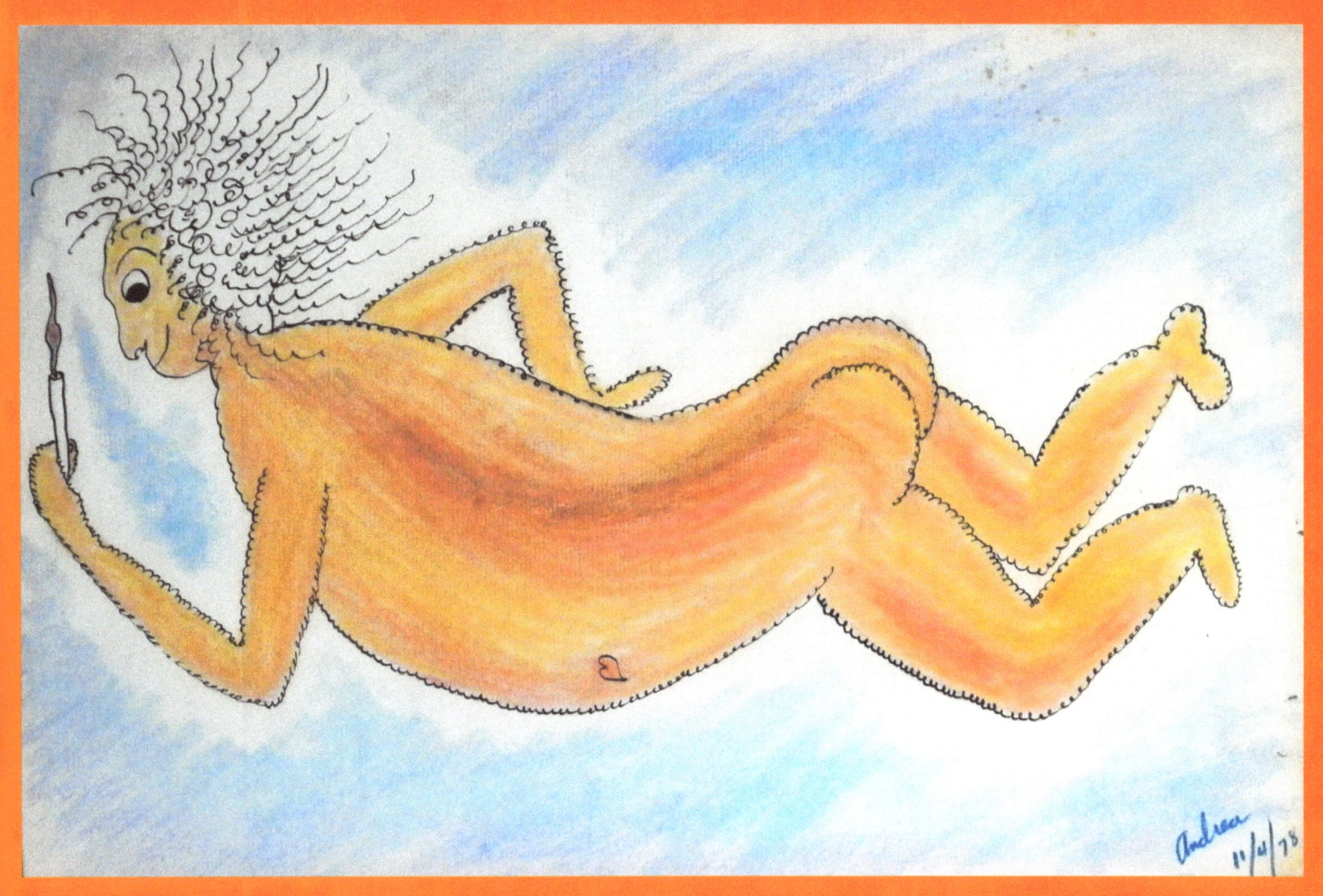

X-Tasy is knowing how to carry your light.

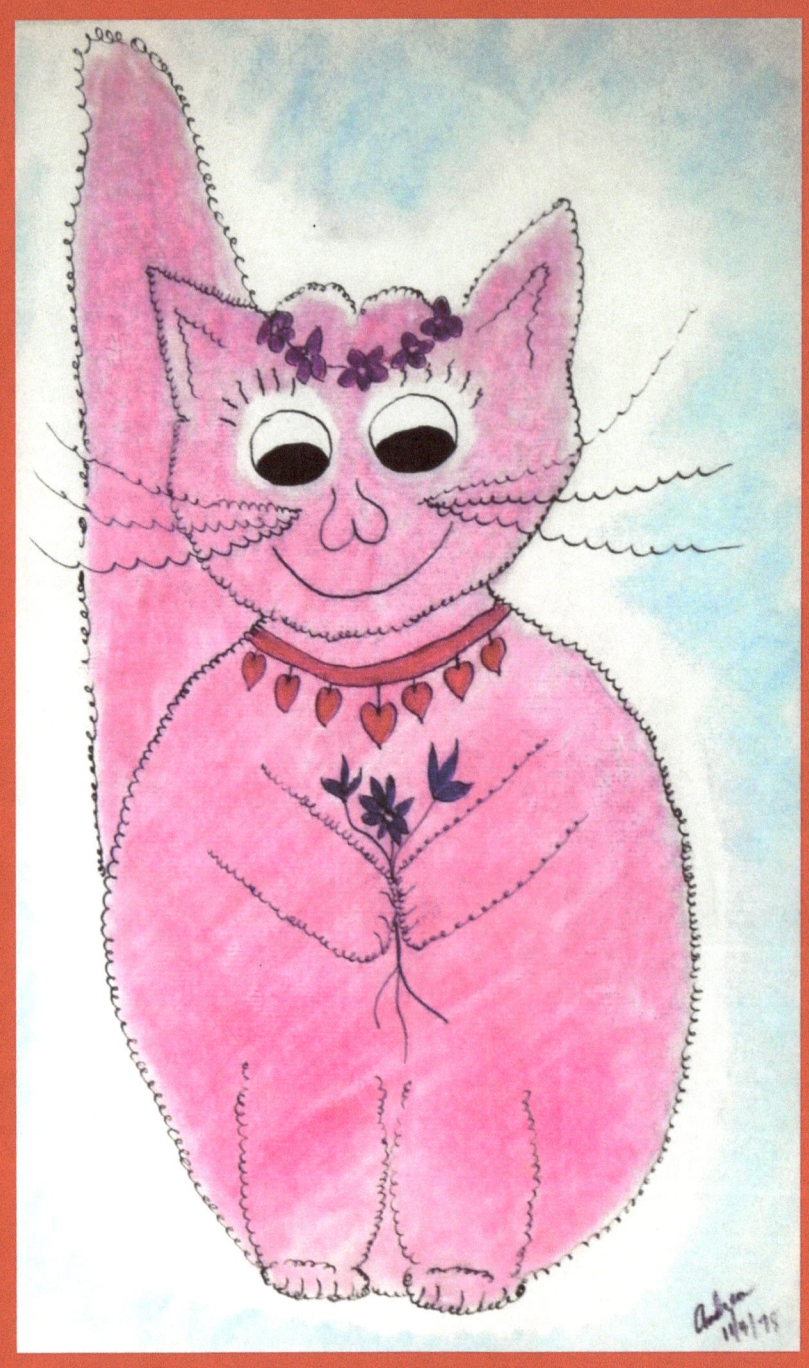

X-Tasy is knowing your cat loves you.

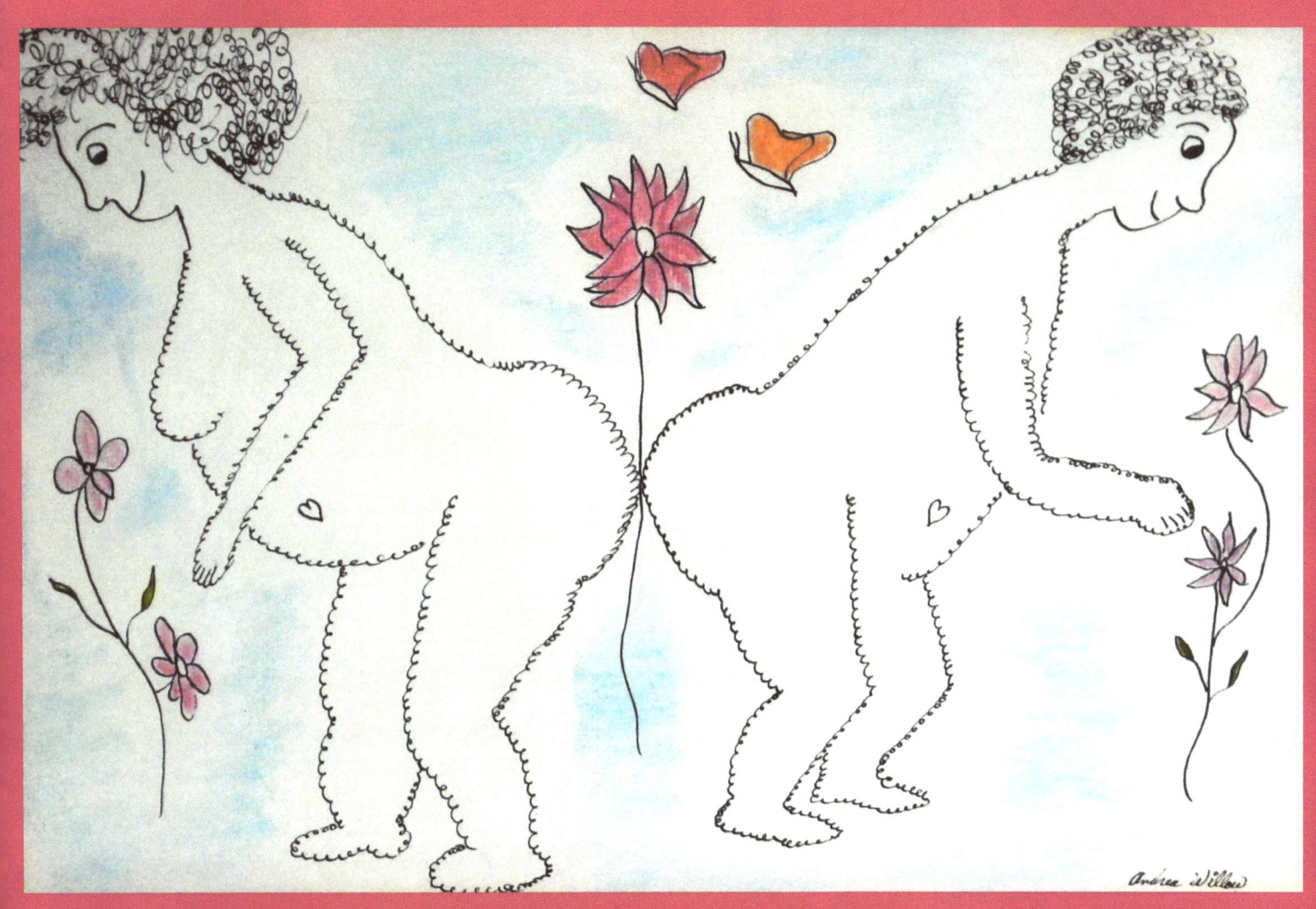

X-Tasy is knowing it's ok to make ends meet.

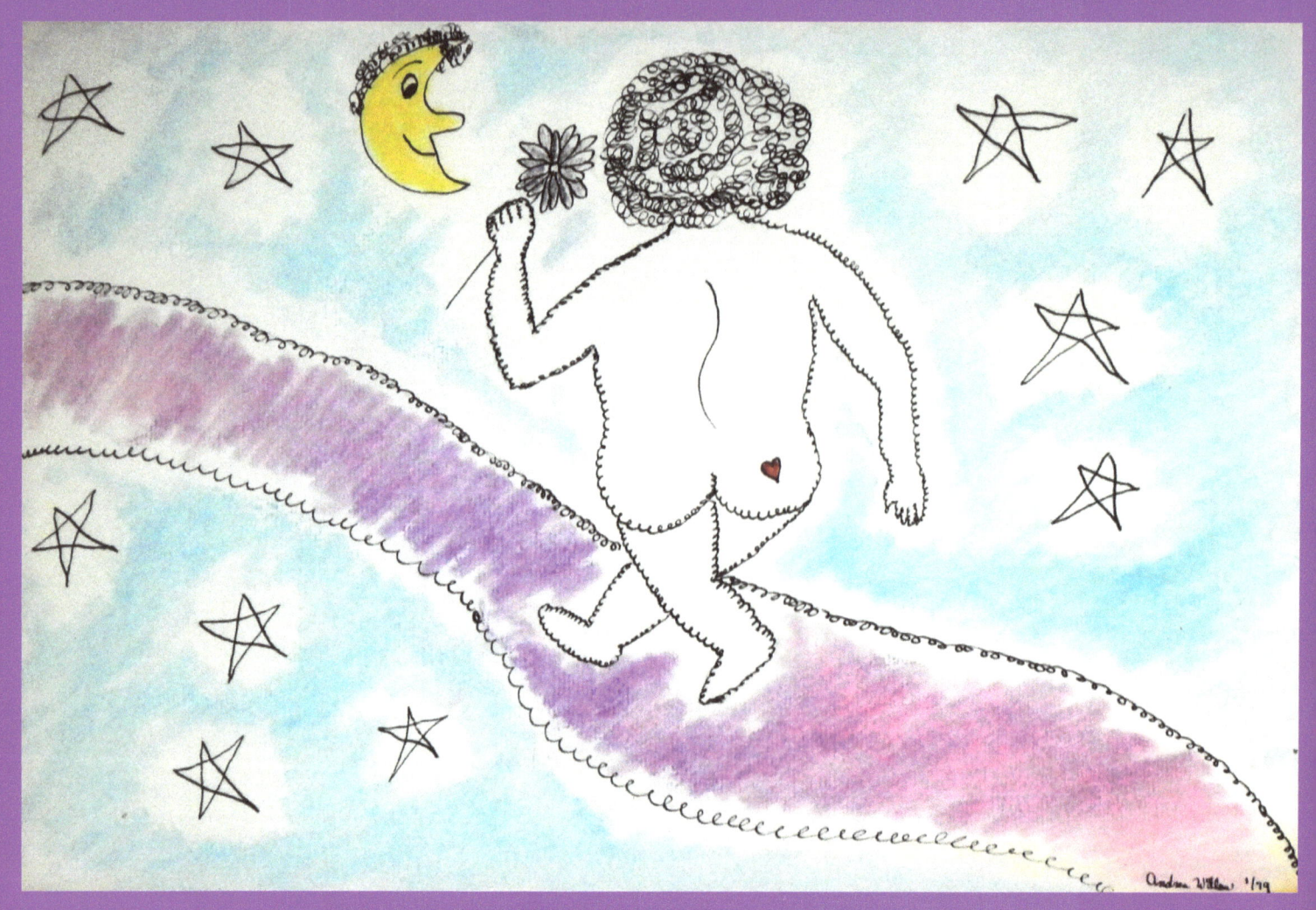

X-Tasy is knowing it's ok to run through your life with your best friend, You!

About the Author –

Andrea L. Willow expresses her dry sense of humor via writing and art and enjoys sharing these talents with others.

She has exhibited her art in Los Angeles, the High Desert, CA and Las Vegas at hotels, high-end boutiques, art shows and galleries. Andrea's art enhances the homes of many private collectors nationwide and internationally.

Born in Chicago, Illinois, she moved to California with her family in 1956. She received her BA from Antioch University, has studied at the Center for Art in Pasadena, CA, and has taken many art classes and private lessons over the years.

Andrea may be contacted by emailing her at picassotp@gmail.com.

WORKS OF ART BY ANDREA L. WILLOW

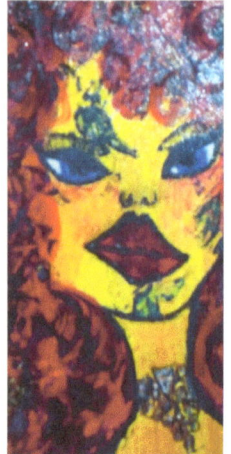
HOT LIPS -- 2012

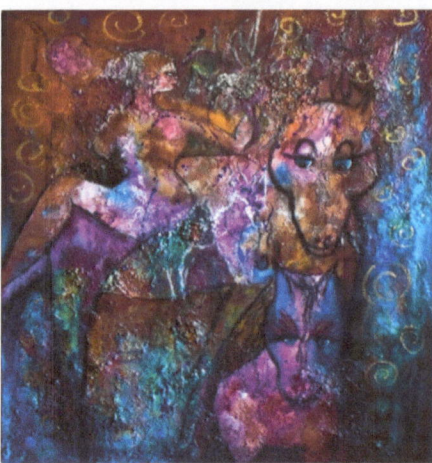
WHOA HORSEY -- 2012

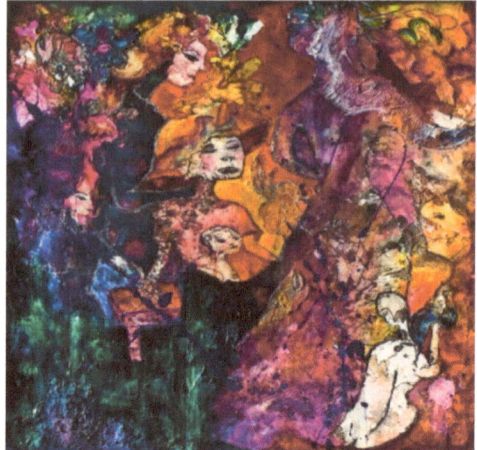
LADIES SHARING -- 2010

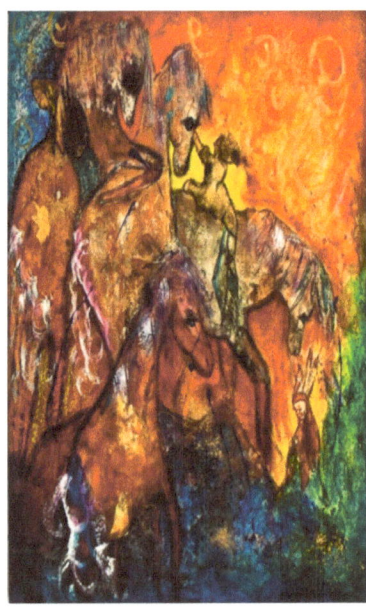
HORSE PLAY -- 2012

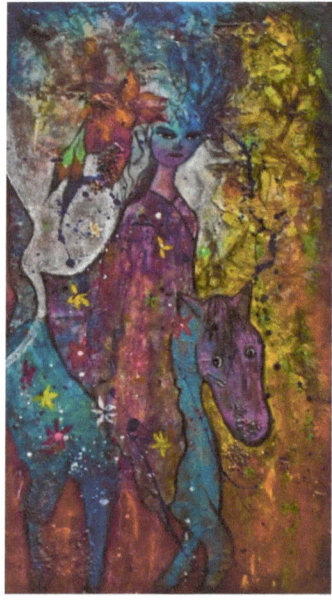
PRINCESS JOURNEY & THE PONY -- 2010

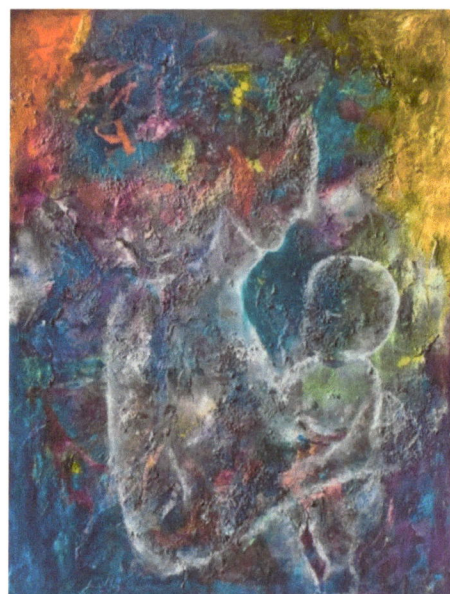
ETHEREAL MOM -- 2010

Visit: www.fineartamerica.com Contact: picassotp@gmail.com

www.ingramcontent.com/pod-product-compliance
Lightning Source LLC
Chambersburg PA
CBHW050411180526
45159CB00005B/2227